LEARN FROM THE MASTERS
Create your own watercolours
in the style of
PAUL CÉZANNE

The author

Angelika Khan-Leonhard studied art in Freiburg and Ravenna. In 1975 she founded her own art school in Hinterzarten, Germany, and from 1985 she was the director of an art school which she established at Schluchsee in the Black Forest. In 1988 she was appointed to teach oil painting at the Art College, Kashmir.

Angelika has also been acclaimed for her solo exhibitions, which have been held in various countries around the world.

LEARN FROM THE MASTERS
Create your own watercolours
in the style of
PAUL CÉZANNE
Angelika Khan-Leonhard

SEARCH PRESS

Contents

Learn from the Masters

For centuries painters have imitated masterpieces, both to improve their techniques and to develop an individual style, and copying the masters is often an essential part of an artist's training. Of course, it calls for considerable knowledge and skill, and any painter wishing to follow in the steps of the masters must first analyse original works in detail. *Learn from the Masters* has been specially designed to enable you to do just this.

Each book in this series shows how a leading watercolourist actually worked. Learn something about the master's life, how he saw things, and how he used certain techniques of form and colour in watercolour painting. Discover through step-by-step demonstrations how to reconstruct the original picture and how to recreate details of the work in the same way. Find out also how to translate modern views into the same style as the original painting.

As you discover more about the artist and his work, it is likely that you will become more aware of the distance in time that separates you. This will encourage you to develop your own creative style, using the skills and techniques that you have learnt from the past.

Other books in the series feature artists such as Turner, Van Gogh, and Gauguin.

Paul Cézanne

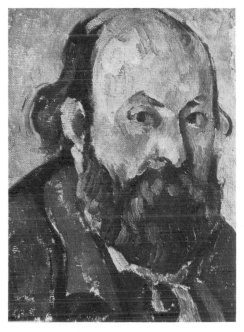

Life and work

Paul Cézanne was born in Aix-en-Provence on 19 January 1839. At the time, his father, Louis-Auguste Cézanne, was a hatter, although he later became a successful banker. Paul's mother, Anne-Elisabeth-Honorine Aubert, was his father's housekeeper. His parents did not marry until 1844, after the birth of their daughter Marie.

In 1852, Paul entered the Collège Bourbon, a secondary school which stressed the humanities and religious instruction, and it was here that his long friendship with Emile Zola began. At this time, Paul also attended drawing classes at the museum, his longing to become a painter growing steadily.

In 1858, Cézanne began to study law at Aix-en-Provence, but he soon gave it up to work in his father's bank. He also took advantage of long visits to Paris, where he met Zola once again. Whilst in Paris, Cézanne worked at Père Suisse's free art school, where he had to pay only for models, and it was here that he met Pissarro. This friendship not only confirmed Cézanne in his choice of career, for he suffered

greatly from self-doubt, but it also gave him new ideas.

Cézanne's attempts to enter the illustrious École des Beaux-Arts were unsuccessful, and the official Salon rejected his paintings. Together with his new friends Monet, Sisley, Bazille and Renoir, he exhibited at the Salon des Refusés. Cézanne admired the work of Delacroix and Courbet, and he was enthralled by Romanticism. He painted a great deal and produced his first still-life pictures.

During the Franco-Prussian War, Cézanne took refuge with a painter's model, Hortense Fiquet, in the village of L'Estaque, a small port near Marseilles. There, he became increasingly devoted to open-air painting, that is, working directly from nature. After the war he moved to Auvers-sur-Oise, to be near Pissarro and to learn from him. He finally deserted the romatico-baroque style of painting and sombre tonality which had affected his work between 1863 and 1870.

In 1874 the first Impressionist exhibition was held in Paris. Cézanne showed his work there but the critics

5

jeered at it. His paintings were also rejected when he showed them in the third Impressionist exhibition. He withdrew and spent subsequent years alternately in Provence and in the Paris region. It was during this period that he discovered his own style.

In 1886 he married Hortense Fiquet, who had given birth to their son Paul in 1872. Louis-Auguste Cézanne died in the same year, his legacy finally solving the financial problems of the painter and his family.

Cézanne began to exhibit more often, and in 1882 the Salon finally accepted one of his portraits. In 1895 the art dealer Ambrose Vollard organized an exhibition of Cézanne's works. Cézanne received considerable recognition from other painters, although in general he remained without public acknowledgement.

In the years that followed, Cézanne produced five versions of *The Card Players*, and the *Bathers* series. He painted views of the Arc Valley and of Mont Sainte-Victoire. His fame spread beyond France, and the National Gallery in Berlin acquired one of his landscapes.

Emile Zola died in 1902, although his friendship with Cézanne had ended some years before. Cézanne was shocked by the way in which Zola portrayed him in his novel *L'Oeuvre*.

Cézanne was triumphantly successful at the 1904 Autumn Salon, where he was given an entire room to himself. At the next Autumn Salon he exhibited his large *Bathers*, a work which had taken him seven years to complete.

Cézanne bought a property to the north of Aix-en-Provence, where he spent a somewhat reclusive life. On 15 October 1906 he collapsed on his way home, after a heavy storm had interrupted his work. He died a week later, on 22 October 1906.

Watercolour techniques

Paul Cézanne was a pioneer of watercolour painting in the period of classical modernism. His techniques helped him to abandon the modes of academic classicism and to achieve a unique form of representational art. A fundamental aspect of his success was his unrelenting study of nature and his almost scientific analysis of visual impressions. The absolute simplicity with which he reproduced forms and his ascetic choice of colours were revolutionary.

Cézanne came to believe in and practise Pissarro's use of colours as the actual medium of painting. The dynamics of colour as mass and of colour contrasts became his means of representing space and volume. Pissarro had taught his friend to analyse, filter and arrange colour tones. Starting from the three primaries, Cézanne defined the individual colour tones and applied them in parallel touches, largely dissociated from the natural forms of objects. He wished to represent the coloured aspect of nature produced by light. In the process, light was to be not only a means of illumination, but was to be associated with colours and rendered as something objective alongside them. The lightest areas of a picture were provided by unpainted patches, where the tone of the paper itself assumed the function of light on the coloured areas.

In his watercolours, Cézanne's application of colour in washes and glazes went beyond the outlines of the actual objects used as pictorial elements, and he often repeated and distributed the local colours over the entire surface of the picture. In this way, with a few similar yet clearly demarcated colours, he filled his pictures with harmony and restfulness.

Cézanne's greatest achievement was to no longer merely portray visible reality but to represent form and colour in a new way; as an aesthetically complete, expressive whole.

On the following pages you can discover the ways in which Cézanne built up the composition and colour of his watercolour drawings, using as your example his work *Provençal landscape*. Then, you can examine some modern views, to learn more about Cézanne's methods and find out how his techniques and style can be freely adapted to contemporary subject-matter.

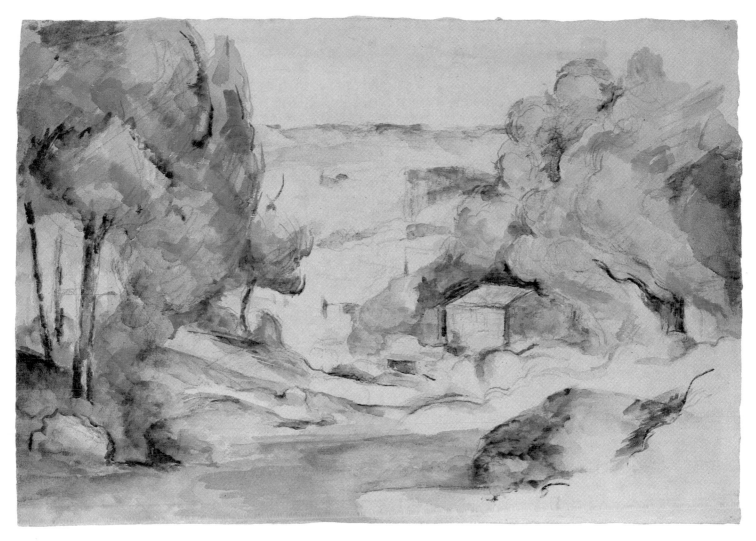

Provençal landscape

Original watercolour by Cézanne

Size: 499 × 346mm (20 × 13¾ in)

Provençal landscape, which was painted around 1878, is one of Cézanne's most significant landscapes in watercolour. Here, colour mass and empty areas, light, air, and landscape details form a balanced whole. Cézanne reproduced the rays of southern light with carefully planned mixtures of the three primary colours: yellow, red and blue. The curves of the vegetation, which are clearly demarcated, form the skeleton of a complex of blue, ochre, green, warm red and violet tones.

This watercolour is a predecessor of Cézanne's later landscapes, which are much closer to abstraction and rely on an almost geometrical construction for their effect.

Materials and equipment

The materials and equipment that you will require to create your own watercolours in the style of Cézanne are relatively few and inexpensive.

Paper: smooth handmade or artist's watercolour paper.

Artist's watercolours: lemon yellow, cobalt blue, rose madder (genuine rose madder is expensive, but there are many suitable synthetic substitutes which can be obtained easily). All tones can be mixed from these three colours. However, if you prefer then you can also acquire yellow ochre and burnt umber.

Brushes: pointed hair brushes nos. 2, 6, 9 and 12, flat-ended hair brushes nos. 8 and 10.

Other equipment: 3B pencil, soft eraser, water trays, artist's palette, drawing board, roll of gummed paper tape, natural sponge.

Drawing techniques

For Cézanne, pencil drawing was an essential supportive element in painting, and his pencil work was both sensitive and fluid.

For the sake of clarity, I have made the pencil work in my demonstration pictures much stronger than Cézanne's.

Paper stretching

Any cockles or wrinkles in the surface of your paper will affect the application of your paint. Therefore, it is a good idea to stretch the paper before using it, particularly when it is over 180 × 240mm (7¼ × 9½ in) in size.

Cut four strips of gummed paper tape, each a little longer than the edges of the sheet of paper. Moisten the paper thoroughly, either by dipping it in a tray of water or by holding it under a running tap. Allow the surplus water to drain off, then lay the paper flat on a smooth drawing board. Use a sponge to smooth away any bubbles, working from the middle outwards. Leave the paper to expand for approximately five minutes, then fix it to the board by sticking the gummed paper tape along its edges. It will take approximately six hours to dry.

Toning the paper

Cézanne often laid a preliminary ground on his watercolour paper or chose sheets which were already toned. However, when exposed to light over a period of years white paper turns yellowish or becomes somewhat browned, and, in some instances, it may be due to this factor rather than to any deliberate colouring that Cézanne's ground appears to be toned.

To achieve something like the present-day effect of Cézanne's watercolour paper, apply a thin, transparent wash of a warm tone to your white paper.

Colour

Since watercolours from different manufacturers usually vary slightly in tonal value, it is worth testing your colours on a sheet of white paper before using them on the work itself.

Brushwork

After making the initial drawing or laying a ground, apply the colour to the larger areas with a no. 10 brush. Work with small strokes or touches applied close to one another. This method contributes greatly to the dynamics of the picture, and, in general, the tonality of this layer is much stronger than the initial wash.

As Cézanne was right-handed, he painted from left to right, and his watercolour strokes were very like those he used when applying oils. When seen together, these relatively small complexes form a whole.

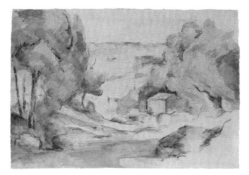

Reconstruction after the original

Size: 500 × 345mm (20 × 13¾ in)
Colours: lemon yellow, cobalt blue, rose madder, yellow ochre, burnt umber. If you wish, then you can replace yellow ochre with a mixture of lemon yellow, a light cobalt blue and rose madder. You can mix burnt umber from cobalt blue, rose madder and a little lemon yellow.

This landscape contains two large colour complexes:
a. The rather heavily painted areas, amongst which are the groups of trees to the right and the left, and the water.
b. The colour of the paper, the empty areas and the smaller colour complexes, which provide light and depth.

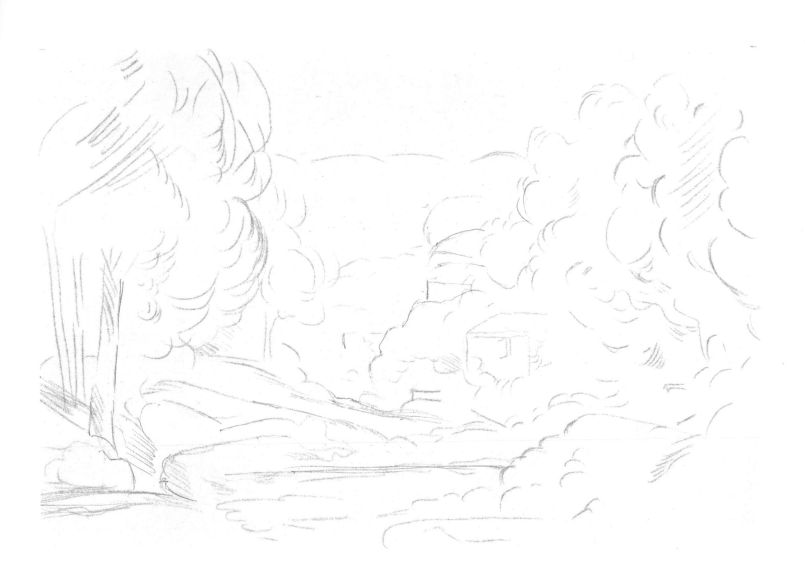

Stage 1

Apply a well-thinned tone of yellow ochre and a little lemon yellow to the white paper.

When this is dry, make your pencil sketch using fluid and gentle strokes.

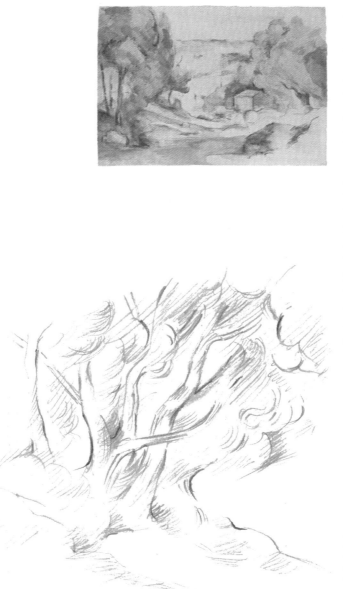

Stage 2

Use a mixture of burnt umber and yellow ochre to create the deep and shadowy tones of the chain of mountains in the background. Use a flat brush for this and work with a broad and liberal touch. Next, draw the colour downwards with a water brush.

Without moistening the paper in advance, colour the groups of trees to the right and the left, together with the undulating areas in the foreground. Use the same mixture as before but in a stronger concentration, and watch out for colour nuances. If you apply a tone twice, then you will add depth to the shadowy areas. This will help you to achieve a plastic effect even at this stage.

Detailed pencil studies will help you to grasp the characteristics of the landscape.

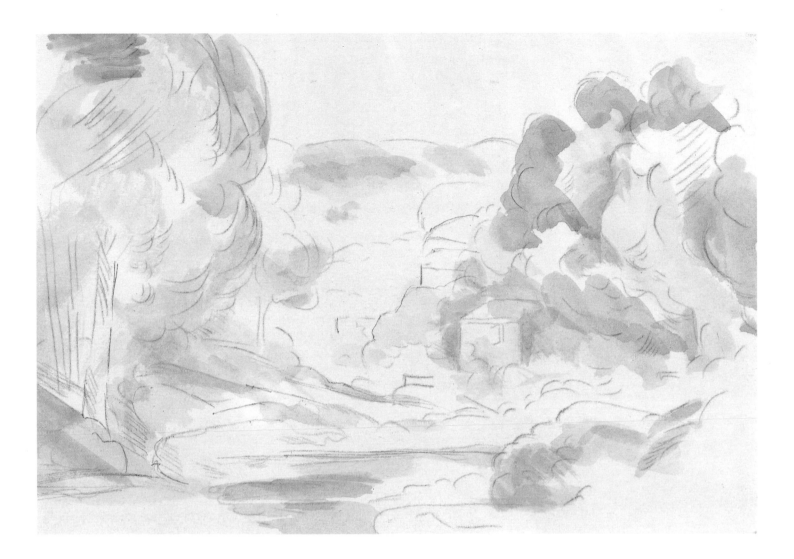

13

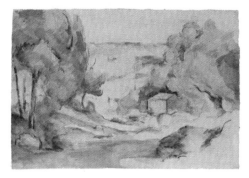

Stage 3

Apply cobalt blue here and there to the brownish washes, varying the degree to which you thin the colour. When painting the chain of mountains in the background, make sure that you paint clear blue areas. In other parts, however, use a water brush to produce gentle transitions to the brown tones.

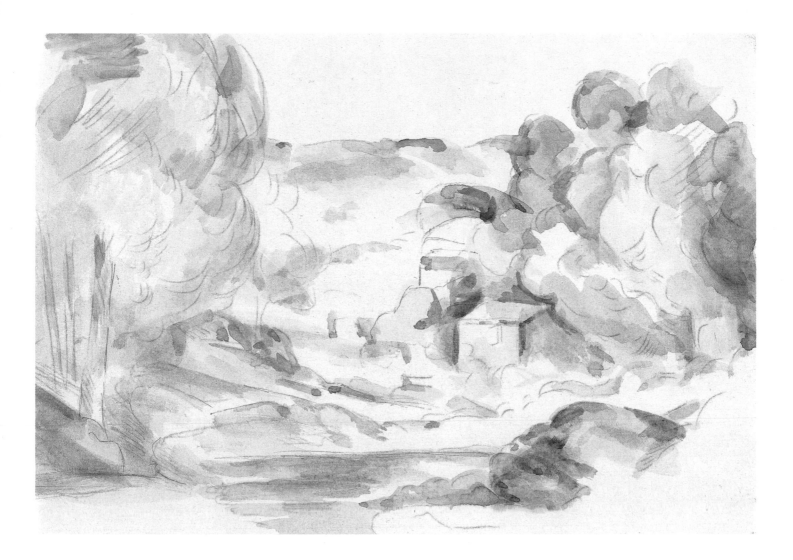

15

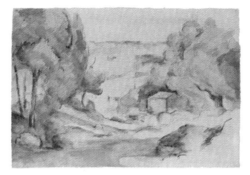

Stage 4

Paint the sky at the upper edge of the picture in the same tone of cobalt blue, working horizontally and using your brush gently. If you moisten the areas below with a water brush, then the colour can run gently.

Paint the crowns of the trees to the right, the left, and in the foreground, using a lightly thinned tone of yellow ochre. When this is dry, apply a green tone, mixed from cobalt blue, lemon yellow and a little burnt umber, to parts of the crowns. For deeper shadow effects, add more cobalt blue to this tone. Again, use a water brush for gentle colour transitions. Heighten the outlines slightly with the point of the brush.

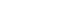

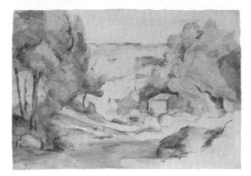

Stage 5 – the finished painting

Intensify the shadows above the house and in the foliage of the tree on the right-hand side of the picture, using a mixture of burnt umber, rose madder and cobalt blue. Work partly with the flat area of the brush and partly with the point. For finer lines, use a no. 2 brush. Lighten the colour here and there with water.

Finally, emphasize the little fisherman's cottage with a light reddish tone mixed from rose madder and yellow ochre.

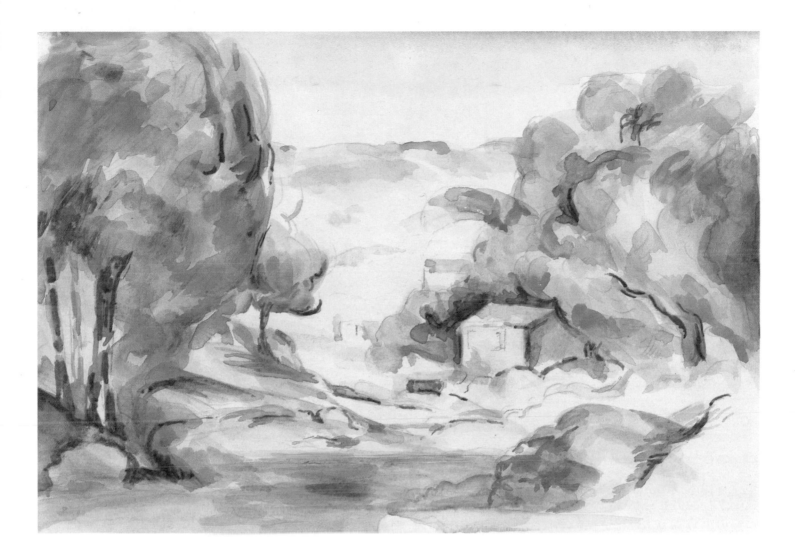

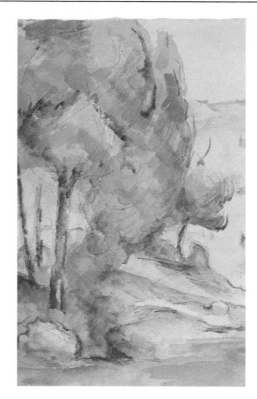

Colour the paper with a warm tone of yellow ochre and rose madder.

As soon as this is dry, make the preliminary drawing with relaxed pencil strokes.

Detail from the original: group of trees

Size: 220 × 300mm (8¾ × 12in)
Colours: lemon yellow, cobalt blue, rose madder, yellow ochre, burnt umber

Make a mount from two movable paper right angles and use this to select details from Cézanne's original painting, which can then be developed into compositions in their own right. The lack of minute detail helps to make such images impressive.

The detail chosen here to be developed into a new composition focuses on the group of trees on the left-hand side of the original painting. The proportions have been changed to give the picture a graceful effect.

The colour of the new composition is relatively close to that of the original, although the greens have been largely dispensed with and this gives the picture a quite different character.

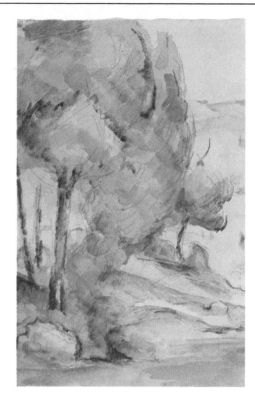

Stage 2

Start to emphasize the main shapes with a mixture of cobalt blue and rose madder.

If you increase the proportion of blue, then the shadow lines will be stressed accordingly. This will result in an impression of space.

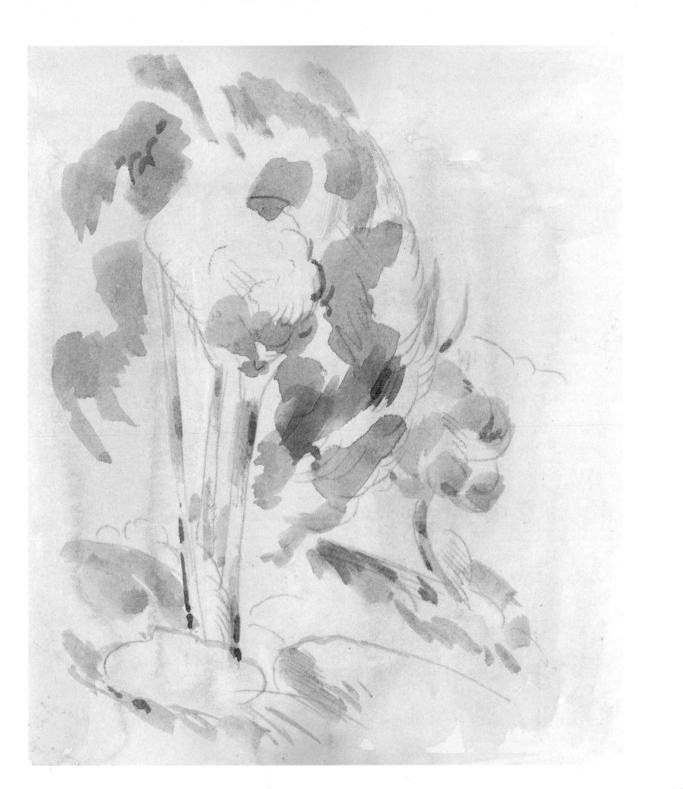

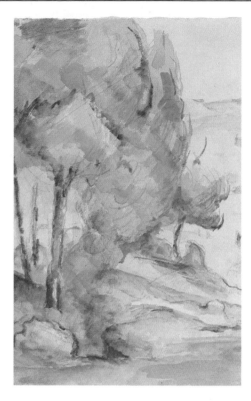

Stage 3

Using a mixture of yellow ochre and a little burnt umber, apply broad, light brush strokes next to and above the violet shadows.

Repeat the same tone in the foreground of the picture.

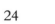

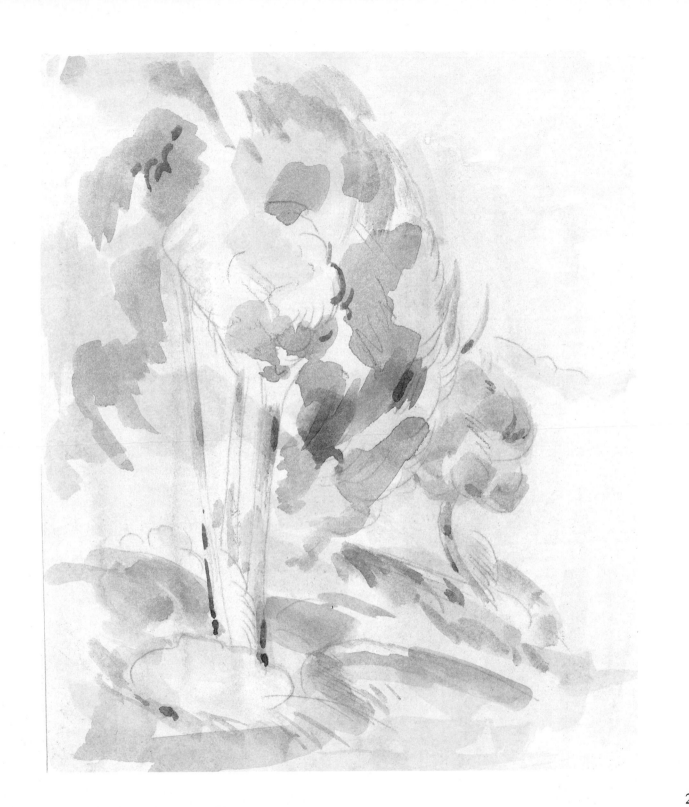

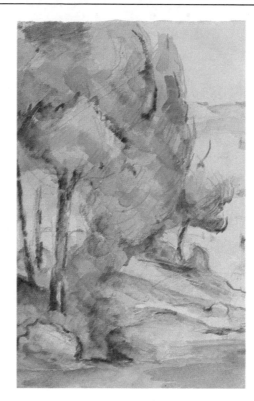

Stage 4 – the finished painting

For the darker shadows of the foliage, use cobalt blue mixed with yellow ochre. To obtain various tonal effects, on some occasions apply all the colour held by the brush and on others simply draw the brush downwards.

The yellowish-green tone of the leaves which are in sunlight should be mixed from cobalt blue, yellow ochre and lemon yellow. Apply pure lemon yellow to a few intermediate areas.

Finally, add dark outlines to emphasize spatial depth and the pictorial structure. Use a fine brush in the direction in which the trees are growing. Mix the colour from burnt umber, cobalt blue and rose madder.

To bring the detail closer to the effect of the original painting, add another layer of a green tone made from lemon yellow and cobalt blue. In this demonstration, this layer has been omitted in order to show an alternative colour effect.

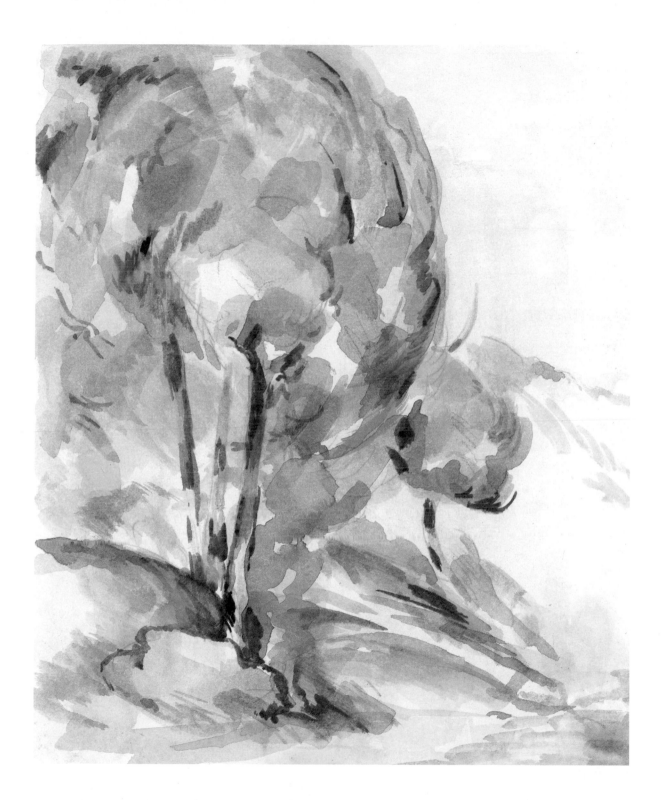

27

Detail from the original: river landscape

Size: 500 × 435mm (20 × 17½ in)
Colours: lemon yellow, cobalt blue, rose madder, yellow ochre, burnt umber

This detail from Cézanne's *Provençal landscape* comes from the middle foreground of the picture.

All subject-matter can be seen in various ways, and this composition has been distanced considerably from the original painting.

Stage 1

Lightly tone the paper with yellow ochre and rose madder, and then complete the initial drawing. Enlarge and emphasize the fisherman's cottage.

The pencil lines should act merely as a skeleton for the colours. If your strokes are too emphatic, then you can soften them later with an eraser.

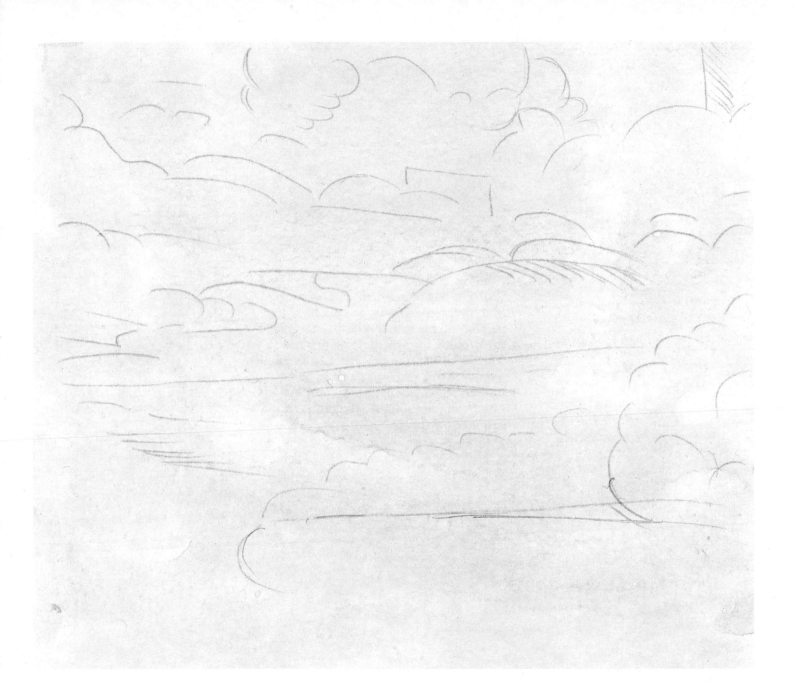

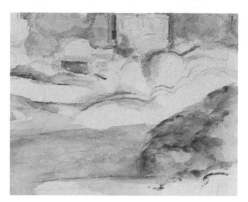

Stage 2

Using a flat hair brush, apply your first layer of colour boldly to the surface of the water, the bank, and the architecture in the background. The dominant ochre tone, mixed from yellow ochre and a little burnt umber, ensures that this composition has a more gentle effect than the original painting.

As an alternative, the buildings can be extended.

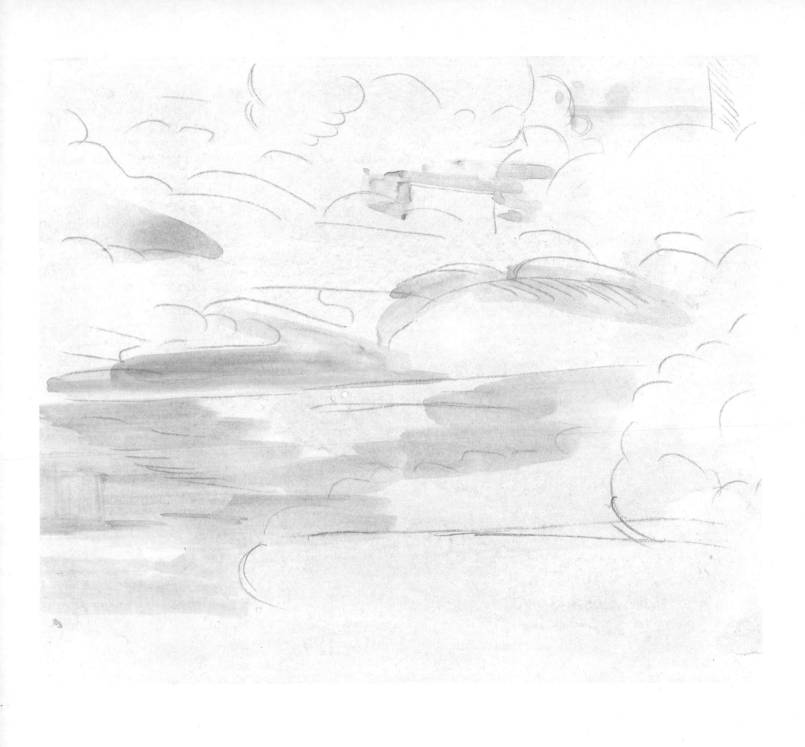

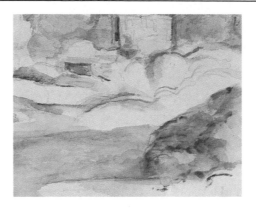

Stage 3

Now apply stronger tones to give the picture a certain plasticity. Use cobalt blue for the outlines, especially in the upper part of the picture. Flat applications of colour in the middle will suggest vegetation. The linear elements divide the picture horizontally but unobtrusively.

The differences between this picture and the original painting, in colour, structure, and brushwork, are already obvious at this stage.

When building up your picture, make sure that the horizontal, vertical, diagonal and round shapes clearly demarcate the basic elements of its structure.

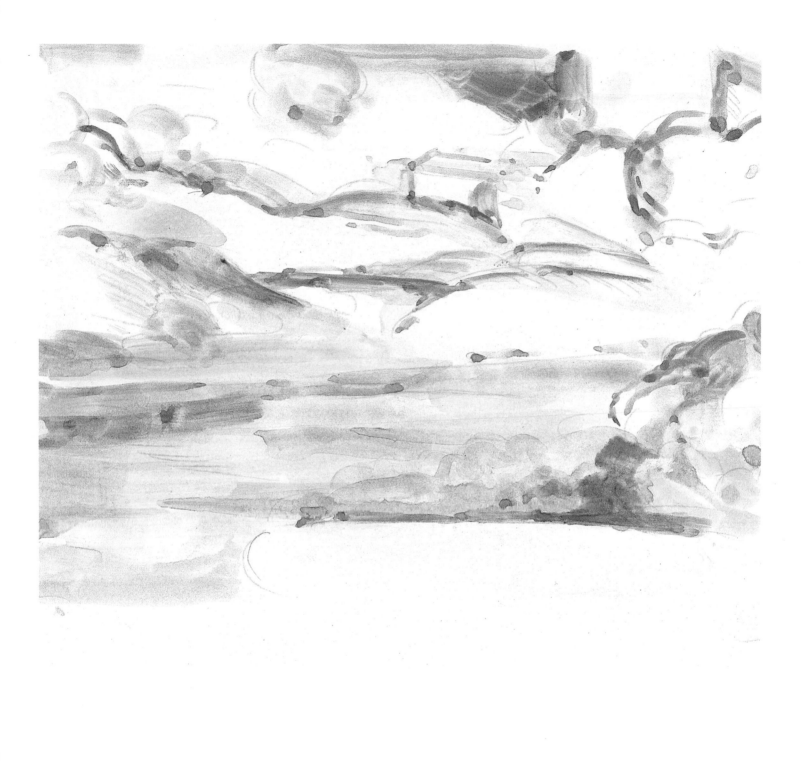

Stage 4 – the finished painting

Apply a loosely brushed green tone, mixed from cobalt blue, lemon yellow and a little burnt umber, to a large part of the areas which have already been painted blue. If you use a fine, clear brush stroke for individual lines, then you will obtain varied tones of green. Use a mixture of burnt umber, rose madder and cobalt blue for the more emphatic lines and shadows. This results in plasticity and depth. Lay a slightly thinner wash over some of the visible brush strokes.

Finally, unite the different parts of the picture with yellow ochre to which a little lemon yellow has been added. You can check the overall effect by turning the picture upside-down or by looking at it in a mirror.

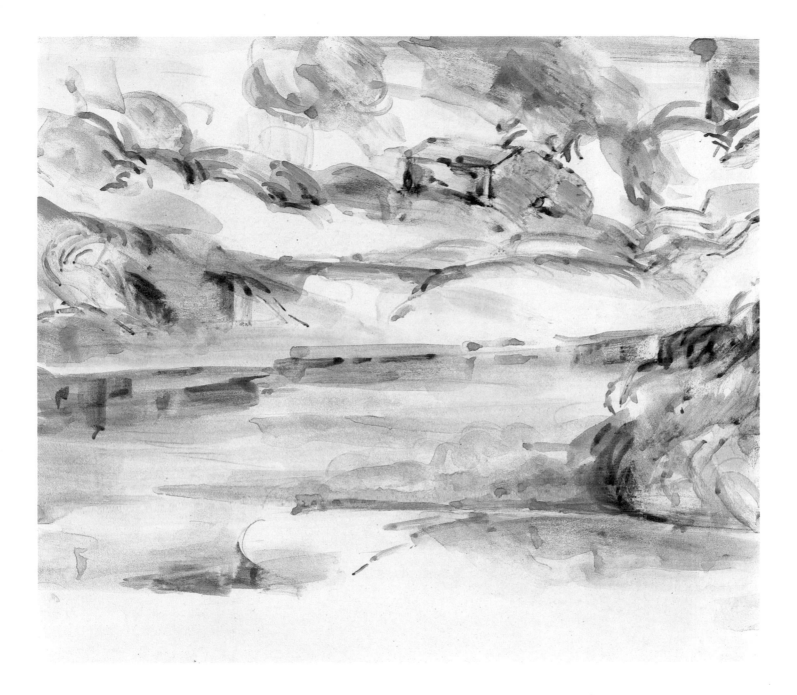

Studies from photographs

Landscape with bridge

Size: 400 × 330mm (16 × 13¼in)
Colours: lemon yellow, cobalt blue, rose madder, yellow ochre, burnt umber

To some extent, this photograph contains the same basic elements as Cézanne's watercolour *Provençal landscape*: the groups of trees, the water, the architecture and the undulating shapes in the foreground.

Cézanne's oil *The Bridge at Maincy* (1879) offers a very similar view.

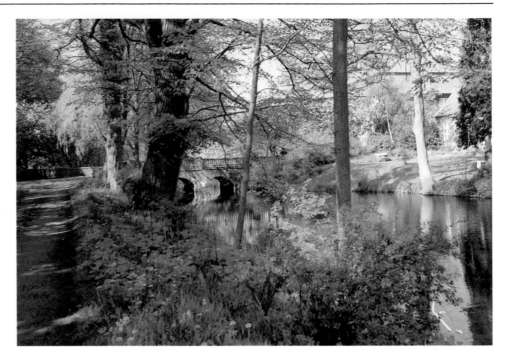

Stage 1

Sketch the landscape boldly in pencil. In this composition, verticals and horizontals dominate, although they are interrupted by diagonals and curves which give a dynamic effect to the picture.

Moisten the paper slightly and apply a well-thinned ground of yellow ochre and rose madder.

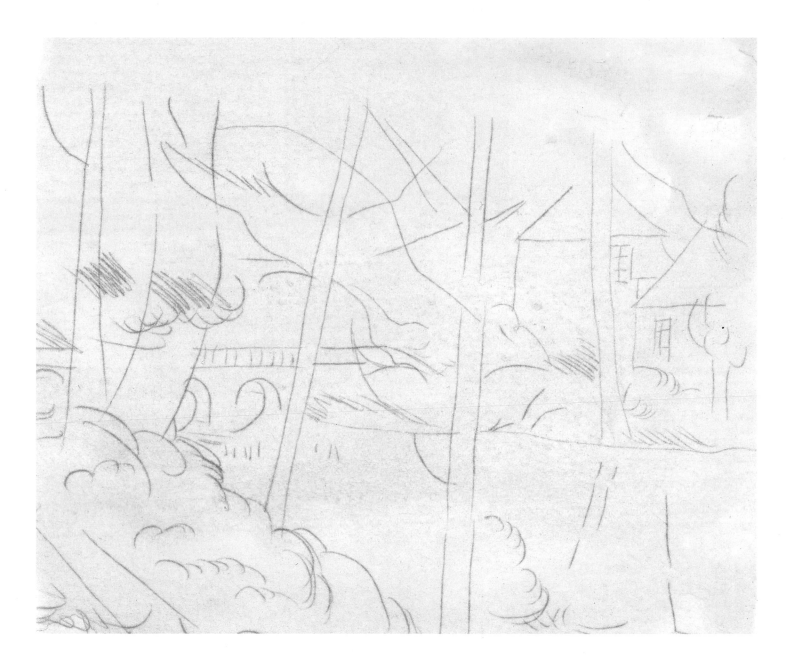

Stage 2

Using a mixture of yellow ochre and burnt umber, apply the first layer of colour with a soft, flat hair brush. In order to vary the direction of the strokes and to obtain a dynamic effect, hold the brush flat at some points and vertically at others. The colour is applied to the foreground and to parts of the background, and thus has a unifying function.

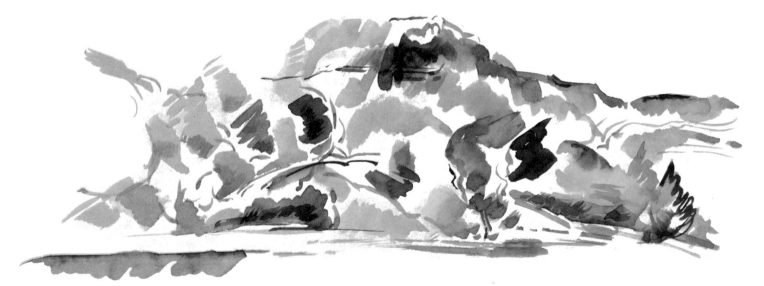

To follow the style of Cézanne's brushwork, apply the colour without interruption and obtain darker tones by repeated application.

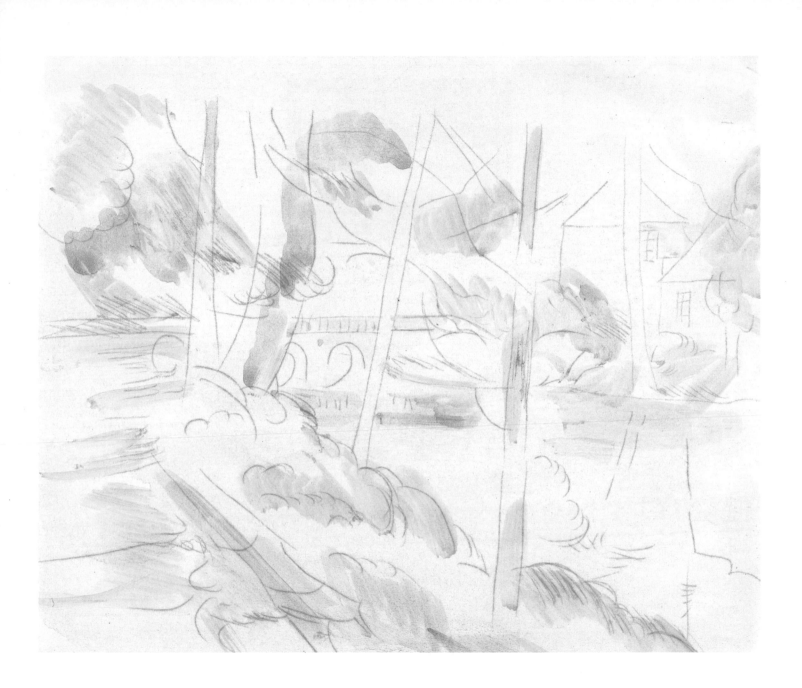

39

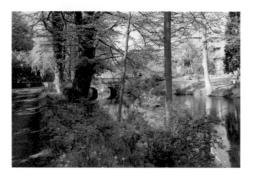

Stage 3

Use a thinned tone of cobalt blue for the rear of the bank and for the sky reflected in the water. Indicate some of the grass areas with the same tone, so that varied green tones will result from subsequent applications of colour. The linear strokes ensure an effect of depth and plasticity without overcrowding the picture. Paint these areas with a dry brush, and keep a rag ready to drain the brush of any surplus colour.

Leave the ground unpainted at certain points. This gives an impression of light, air and breadth.

Repeat the ochre tone, the blue of the water, and the unpainted spots, over the entire area of the picture. This will enable you to achieve the kind of colour harmony typical of Cézanne's work.

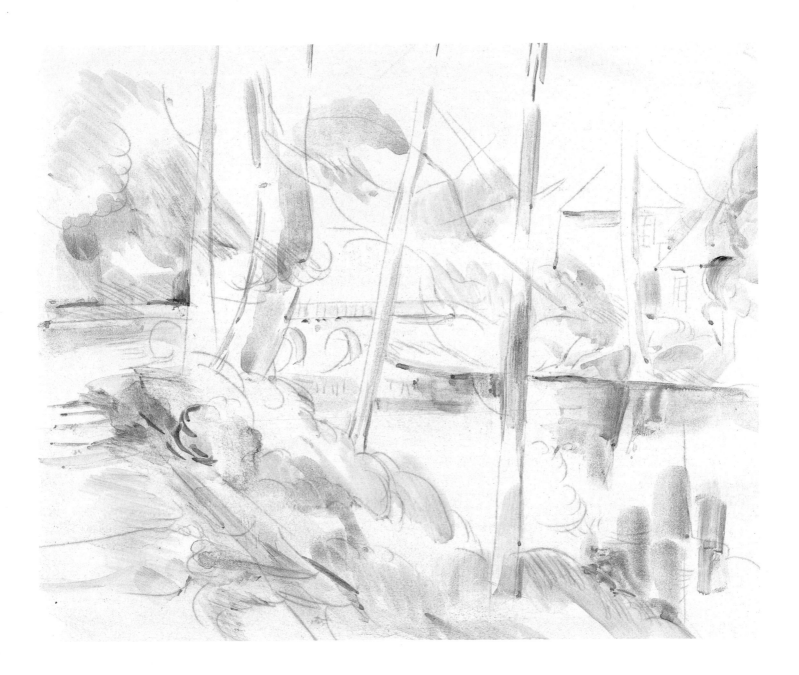

41

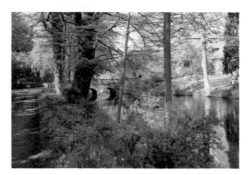

Stage 4 – the finished painting

Emphasize the ochre-coloured areas of foliage with a mixture of cobalt blue, lemon yellow and a little burnt umber. To obtain varying structural effects, apply the brush with differing degrees of firmness, even rolling or slipping it about to some extent.

Use a small amount of a reddish tone, mixed from rose madder and yellow ochre, to give colour to the pathway in the foreground and to the bridge. For the shadowy areas, use a mixture of burnt umber, rose madder and cobalt blue. If you increase the amount of red, then the tone will seem more lively.

The combination of the arches of the bridge, the pathway, and the vegetation in the foreground creates a plastic effect. If you wish, then you can leave the pencil lines in the finished picture, even if you did not cover them up when adding your colour touches or washes. Such lines often increase the vitality of a water-colour.

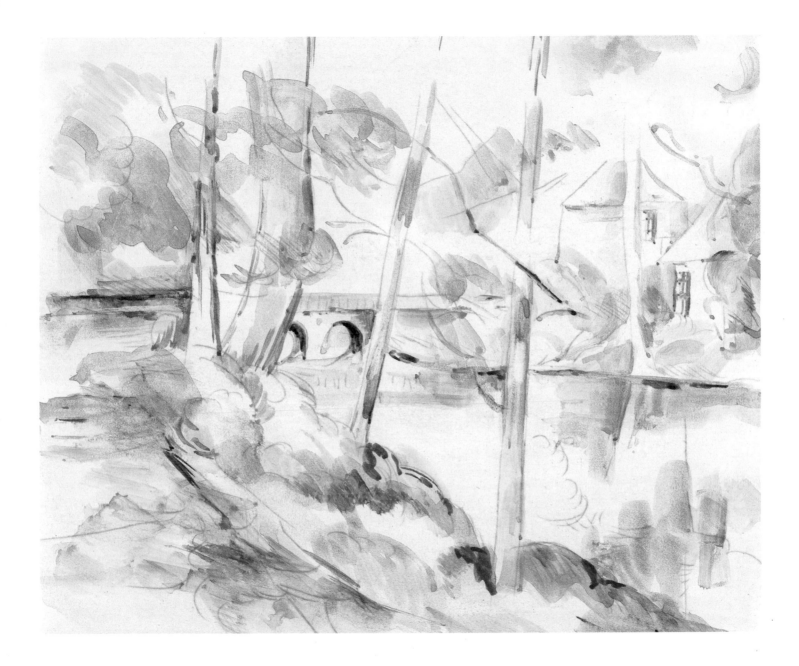

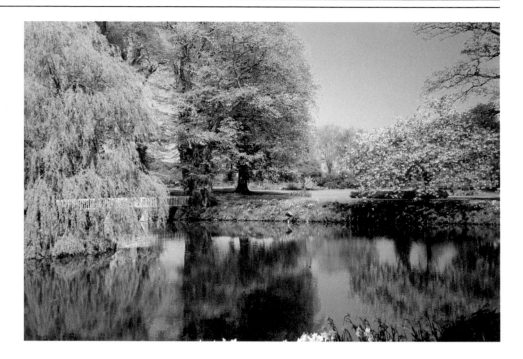

Trees by the water

Size: 400 × 330mm (16 × 13¼ in)
Colours: lemon yellow, cobalt blue, rose madder, yellow ochre, burnt umber

This watercolour was painted in the open air and the subject was photographed later. In such cases it is important to set down the composition roughly at first and then to work it up afterwards. It does not matter if you change the colours of the landscape.

This composition recalls Cézanne's *Provençal landscape*, as it contains something similar to the group of trees and the water on the left-hand side. For the most part, the brushwork and the colour structure of this new watercolour correspond to the demonstration shown on pages 20–27. In each case, the water and the bank play a similar role in the construction of the whole, and the colour values are reduced to a minimum.

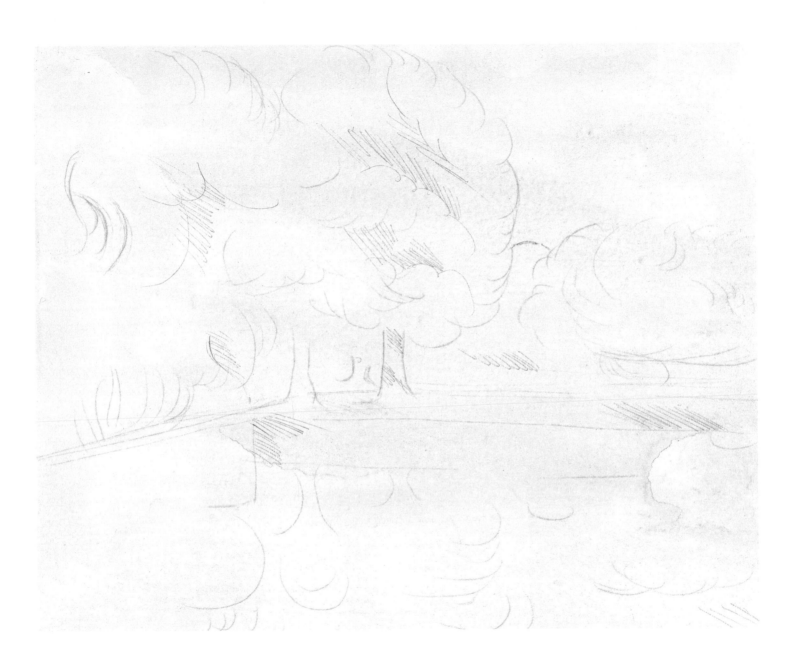

Stage 1

After the initial pencil drawing, lay a ground on the paper with a mixture of yellow ochre and a little rose madder.

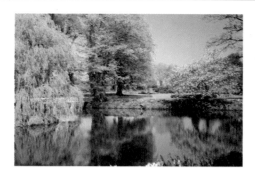

Stage 2

Use yellow ochre with a trace of lemon yellow for the yellow nuances in the trees and the reflections in the water.

When the first washes are dry, mix cobalt blue with a little rose madder and continue to paint the foliage with this mixture. Some areas, such as the tree trunks, need emphatic outlines. At other points, edges that are too obvious have to be toned down using a water brush.

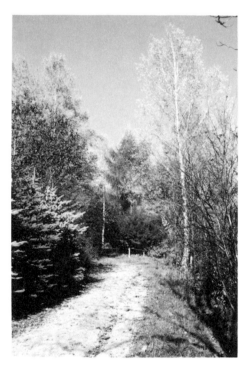

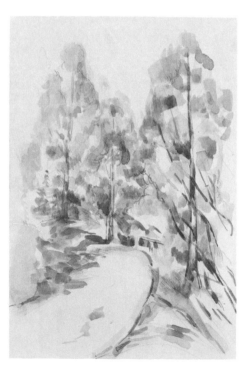

Another example of a landscape and its translation into sketch and water-colour form.

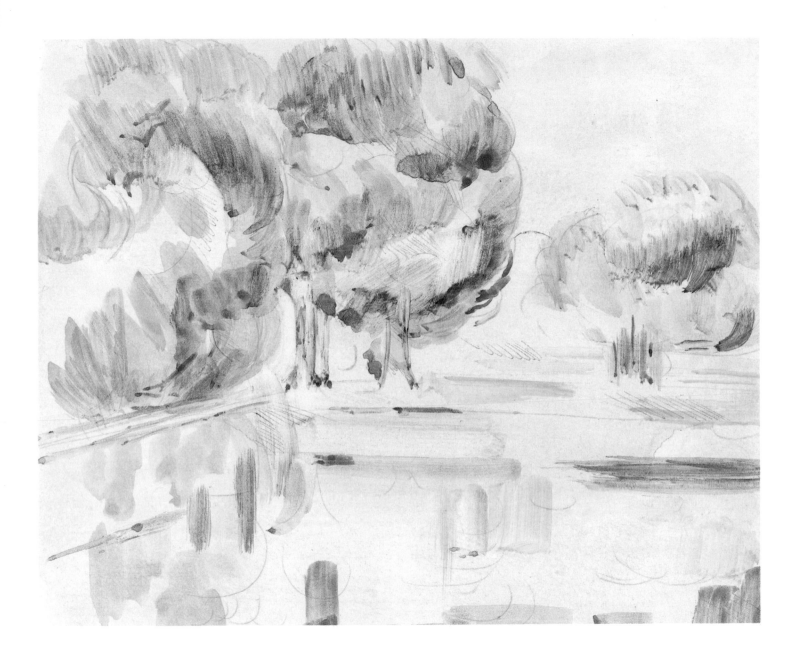

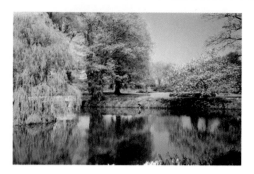

Stage 3 – the finished painting

Finish the crowns and the trunks of the trees, using a mixture of rose madder and yellow ochre. Apply some of this mild red tone to the foreground.

Use a mixture of cobalt blue, lemon yellow and a little burnt umber to introduce colour nuances into the trees and the water. The group of trees at the top left of the picture may seem too compact, so remove some of the colour here using a water brush. This is an effective way of making minor corrections.

Now paint the shadows with a mixture of cobalt blue and a little rose madder. A darker tone would be too strong for this subject-matter.

Apply pure lemon yellow here and there to the trees and the water to add to the impression of a late summer's day. An interesting variety of green tones will also emerge, due to the underlying blue ground.

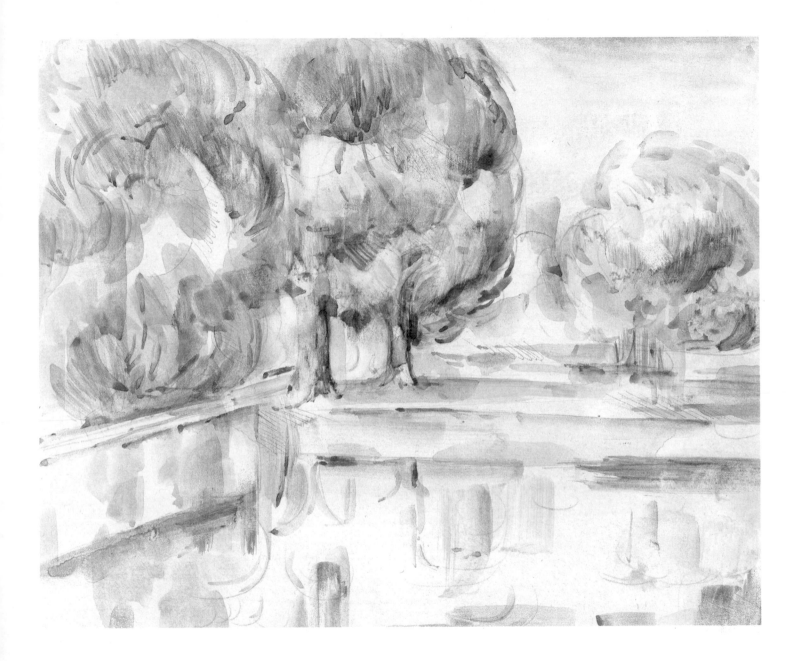

49

The mill

Size: 400 × 280mm (16 × 11¼ in)
Colours: lemon yellow, cobalt blue, rose madder, yellow ochre, burnt umber

This composition relates to the right-hand detail from the *Provençal landscape* (see pages 28–35), although here the emphasis is on the architecture. This watercolour differs from Cézanne's original also in that the tonality here tends to favour red, and more stress is laid on certain details, such as the windows, mill-wheel, and wall.

If you wish, then you can change the colours to create a different mood.

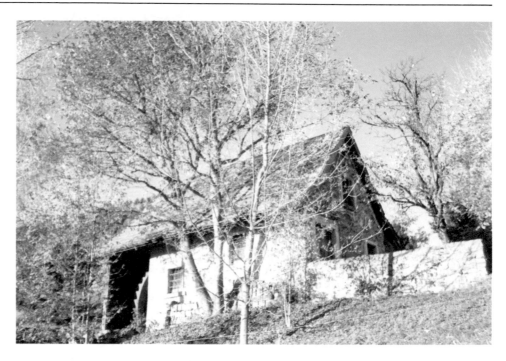

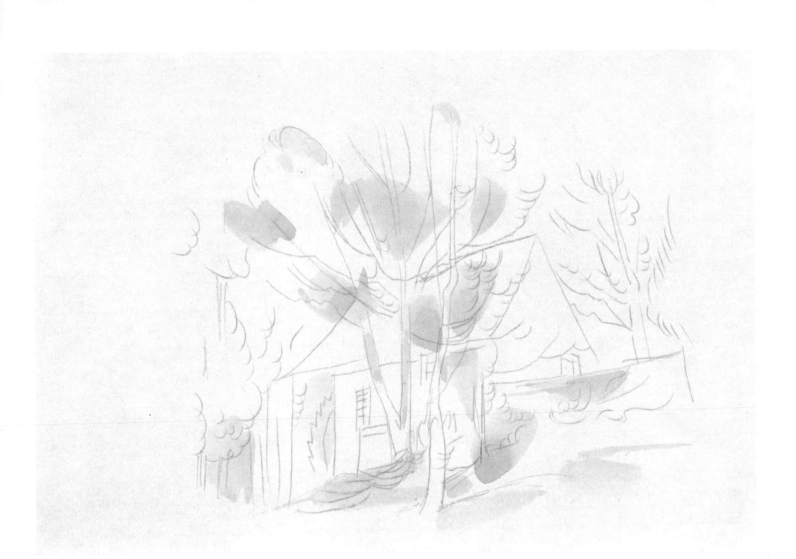

Stage 1

Sketch the architecture using only a few pencil strokes. The drawing is intended merely as a guide to help you to build up the painting.

Lightly wash the paper with the desired tone. In this demonstration a toned paper has been used. It is important to select a relatively smooth surface as this is the only way to achieve the effect typical of Cézanne's work. Next, work boldly on the first shadows, using a mixture of yellow ochre and a little burnt umber. A flat hair brush of the kind used for oils is suitable for this, and it will also allow you to paint with thin strokes. If you strengthen the shadows, then your picture will gain depth. The light-toned areas remain unpainted.

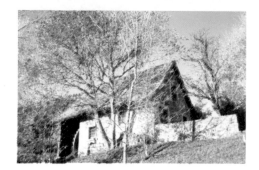

Stage 2

Use a mixture of cobalt blue and rose madder to give more emphasis to the shapes of the trees and the mill. Load your brush with colour once only, and then use it until the colour is exhausted. This will result in varied nuances. Increase the amount of rose madder for the shadowed areas.

Another example of architecture in Cézanne's style. This sketch relates to Cézanne's watercolour *Château Noir* (*c.*1890).

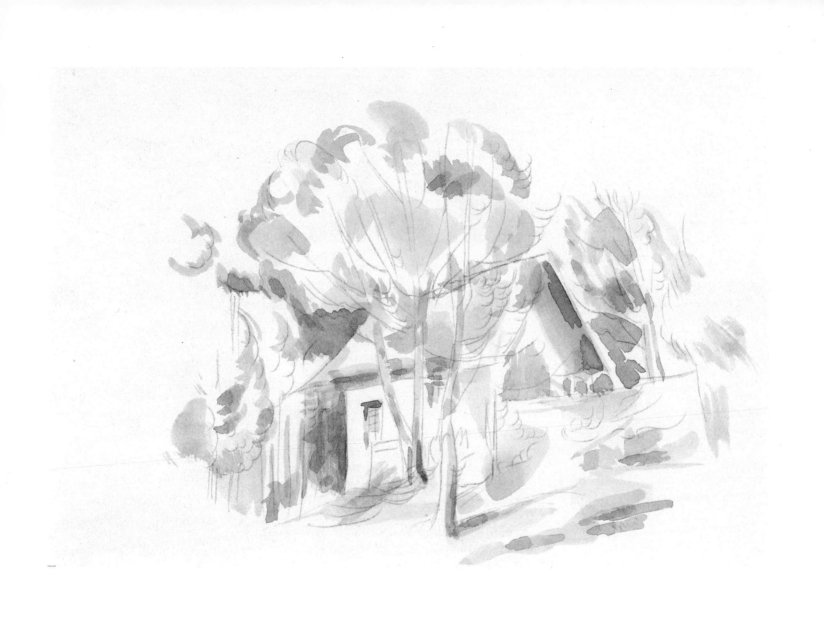

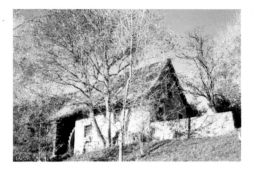

Stage 3 – the finished painting

Use a light green tone, mixed from cobalt blue and lemon yellow, to suggest a springtime mood. Next, overpaint some areas with a mixture of rose madder and yellow ochre. This makes the watercolour more lively.

Mix burnt umber, rose madder and cobalt blue for the sharp outlines and dark edges of the shadows. Pay attention to the way in which the sunlight falls and the shadows work. The shadows create an illusion of depth and thus contribute a great deal to the plasticity of the picture.

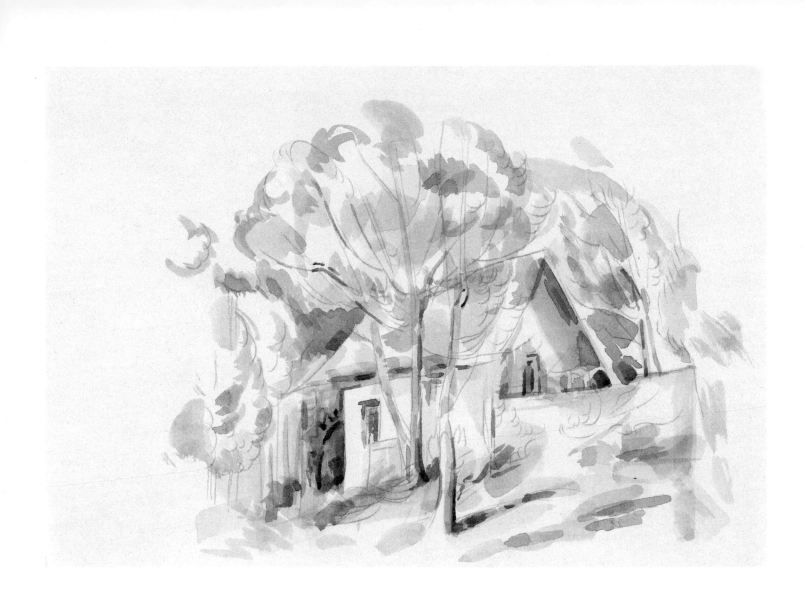

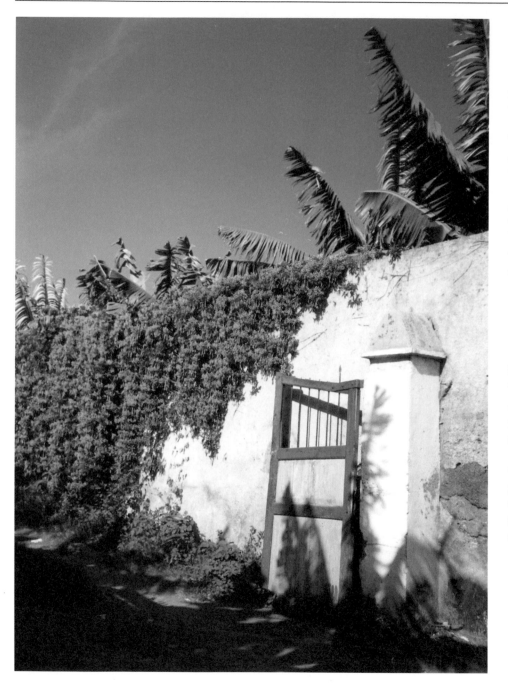

Garden gate

Size: 250 × 380mm (10 × 15¼ in)
Colours: lemon yellow, cobalt blue, rose madder, yellow ochre, burnt umber

This composition, with a wall, a gate and a roadway, resembles Cézanne's watercolour *Entrée de jardin* (1876–8).

As in the photograph itself, light-dark values determine the effect of the composition. The result should be a modern-looking watercolour with a clear structure and only a few colour tones.

Stage 1

The structure of the drawing is especially important here, and it is a good idea to make an exact preliminary sketch (see opposite).

Before transferring the drawing to the watercolour paper, apply a soft ground with a mixture of yellow ochre and a little burnt umber. The significance of this tone will become apparent later (see page 59).

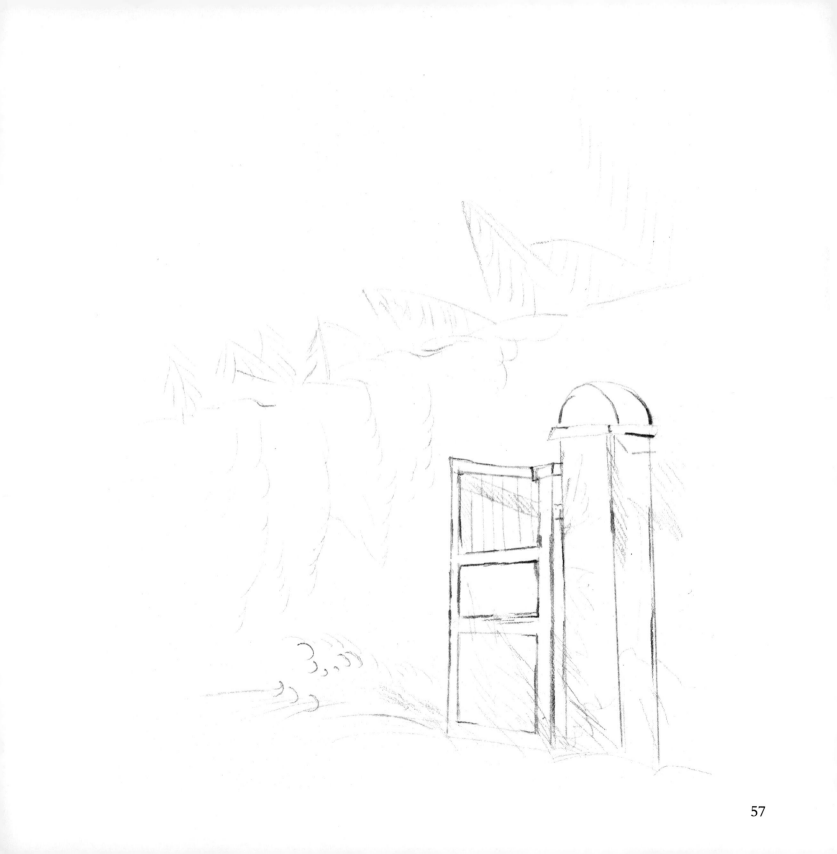

Stage 2

Apply the shadow areas with cobalt blue and a trace of rose madder. The unthinned colour results in especially dark shadows.

Next, mix a warm yellow tone from lemon yellow and rose madder to emphasize the flowers.

You can change the composition easily by stressing the gate even more.

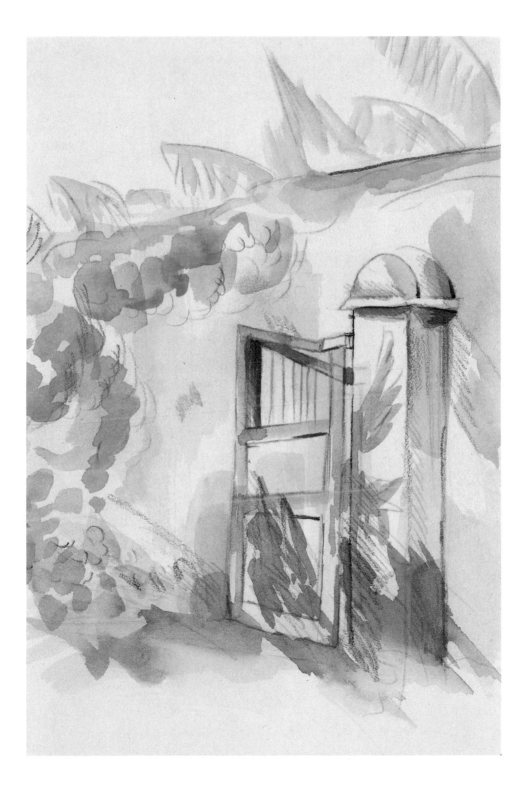

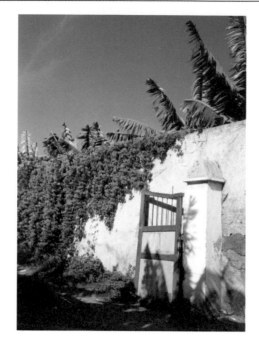

Stage 3

Indicate the sky with a watery wash of cobalt blue and rose madder, applied fluidly.

Next, apply a mixture of cobalt blue and lemon yellow to convey the effect of shadows on the flowers and on the palm leaves. Use the same tone for individual washes on the framework of the garden gate, the post, and the roadway in the foreground. The same mixture, but well thinned, is suitable for the light shadow effects.

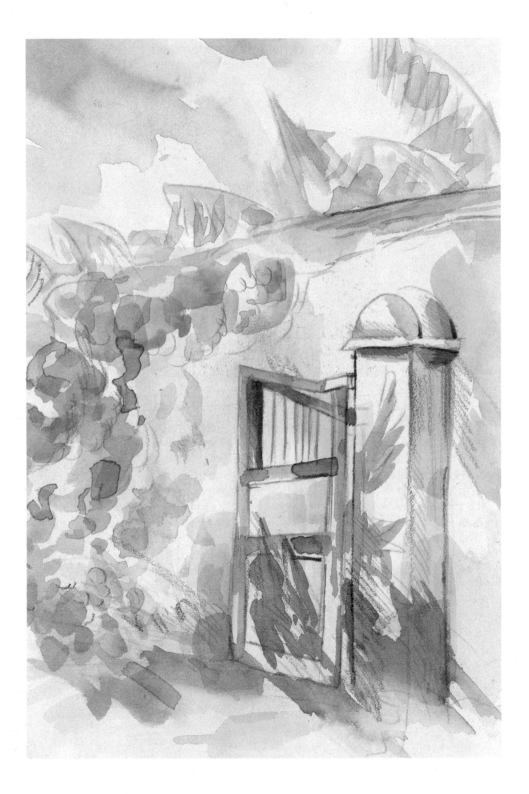

Stage 4 – the finished painting

Shapes clearly delineated in pencil can have a rather harsh effect. To avoid this, use an eraser on heavy outlines and then apply the flat part of the eraser to the entire surface. As the pencil drawing generally remains visible in Cézanne's watercolours, do not remove the lines entirely but merely reduce their effect. The erasure will cause the washes to lose about one quarter of their intensity, so strengthen the tones where necessary.

A comparison of this stage of the demonstration with that on page 61 shows the effect of the pencil work. Depending on whether the graphic or the painterly element is to be stressed, either erase the lines or retain them.

Use a mixture of rose madder and yellow ochre for greater emphasis on the flowers and the foreground. An effect of warmth and depth should result.

To increase the structural effect and the impression of plasticity, stress some of the outlines with a fine line and intensify the shadow areas. For this, use a dark tone of yellow ochre, cobalt blue and rose madder.

Finally, apply some colour accents with a green tone made from cobalt blue and a little lemon yellow.

These few generally distributed tones will determine the ultimate mood of the watercolour, which should radiate harmony and aesthetic balance. The empty areas scattered over the entire surface convey an atmosphere of sunshine and light.

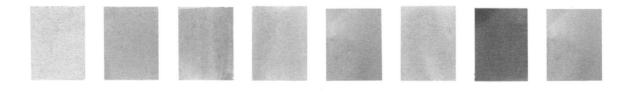

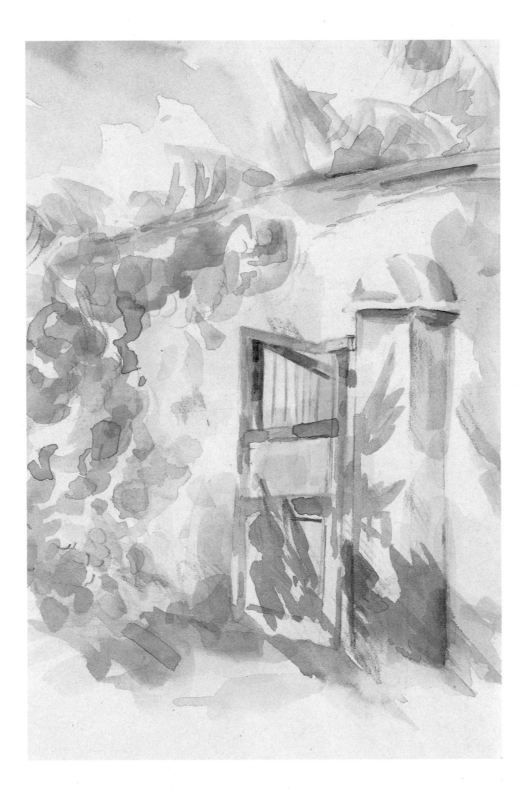

Male Bathers

Original watercolour by Cézanne

Size: 272 × 200mm (11 × 8in)

Cézanne constantly returned to the human form in his pictures, and a few basic themes recur in his figure work. He based the figures themselves on tradition, and represented them as compact and dynamic elements in space.

In later years, the theme of movement became more significant for Cézanne. His heavily stylized figures became harmoniously integrated into the landscape, even seeming to flow into and out of it.

Cézanne's *Bathers* are especially typical of this tendency. He developed the subject of nude male and female figures in a landscape over a period of some forty years and devoted a whole series of compositions to it. Indeed, *Bathers* became the central theme of his major works.

In this example, from the period 1896–7, the bodies of the figures tend to share the paper's tonality. The background colour – blue in this instance – is also that of the body outlines. The constantly repeated colours structure the surface of the picture, rather like the pattern of a carpet.

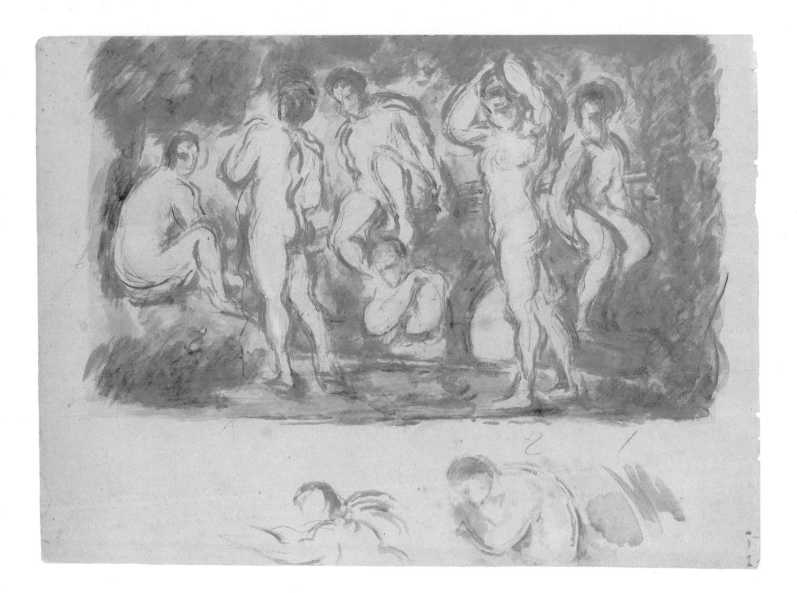

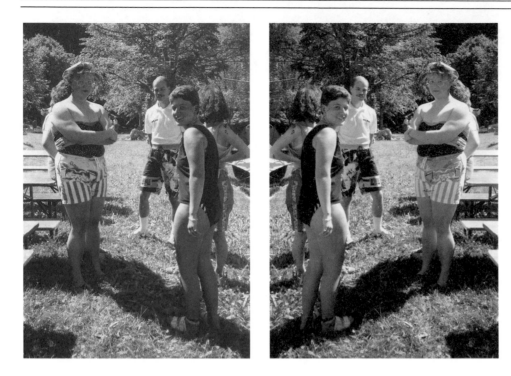

Stage 1

The photographs and the sketch shown here should give you some idea of how to make more of your subject-matter.

Before beginning the pencil work, apply a warm tone of yellow ochre and rose madder to the paper.

Next, sketch the composition, doubling it in the drawing. In other words, draw the group of figures twice, once as they actually appear and once as a mirror image, thus turning four people into eight. To obtain a different effect, you could also change the positions of the figures.

In general, use curved and rounded lines for the bodies and vegetation, and put in only a few straight lines on the arms and legs.

Studies from photographs

Group of figures

Size: 300 × 245mm (12 × 9¾ in)
Colours: lemon yellow, cobalt blue, rose madder, yellow ochre, burnt umber

People engaged in a sport, people camping, people by the sea: there are numerous opportunities to draw groups of people and then transform the resulting sketches into water-colours.

66

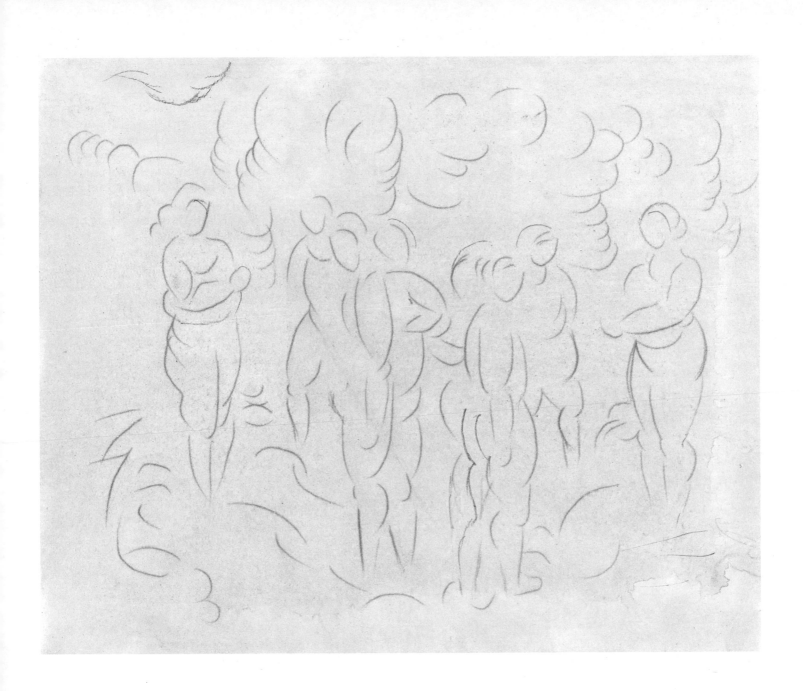

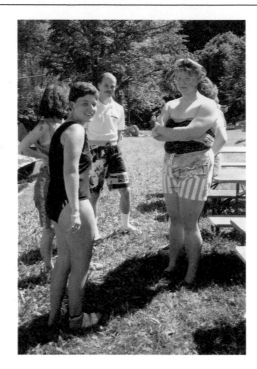

Stage 2

Build up the figures and the crowns of the trees with a mixture of yellow ochre and lemon yellow. Begin with a full brush so as to leave an intensive tone, then remove the surplus colour and apply a wash with a more gentle tone. Draw the colour from the background into the figures, painting over the pencil lines. A bold and sweeping brush stroke will stress the dynamics of the bodies.

Use a mixture of rose madder and yellow ochre to emphasize the warm skin tones.

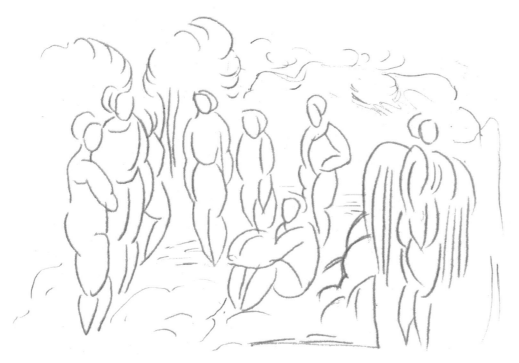

You can vary the composition as you wish by arranging the figures in a different way.

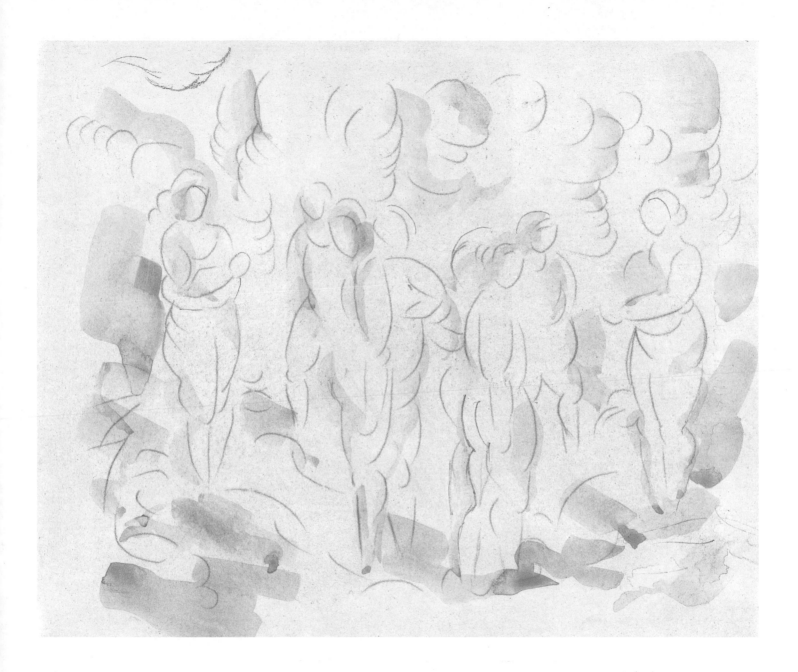

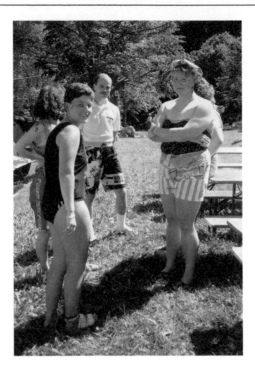

Stage 3

Mix cobalt blue with rose madder for the background washes. Draw the colour along the body outlines to give an effect of plasticity. For the most part, the figures have the same light colour as the paper and thus stand out well from the blue tone.

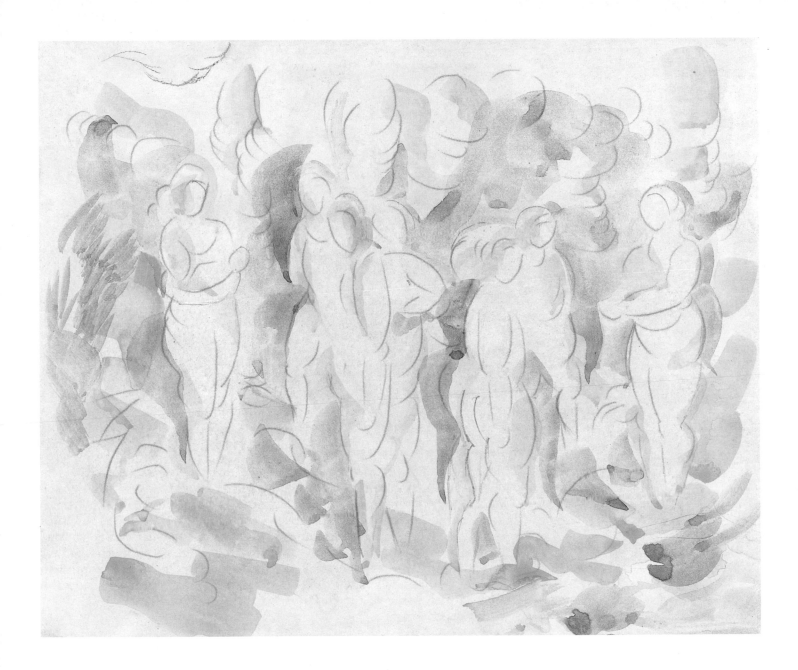

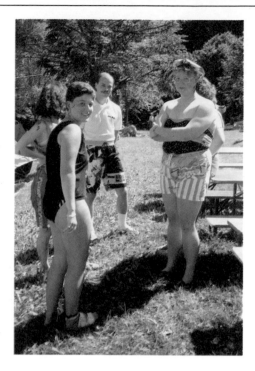

Stage 4 – the finished painting

Outline the figures in pure cobalt blue, using a fine brush. On each occasion use all the paint held by the brush. Sometimes work with the flat part of the brush and at other times use the point. The result will be broad, short, or very fine strokes, and the outlines will have a loose effect. Soften some of the contours with a water brush.

A few reddish washes mixed from yellow ochre and rose madder will give a warm overall effect.

Use a thinned mixture of burnt umber, rose madder and cobalt blue to strengthen a few linear shadows and to create illusions of depth here and there. This will add considerably to the effect of space.

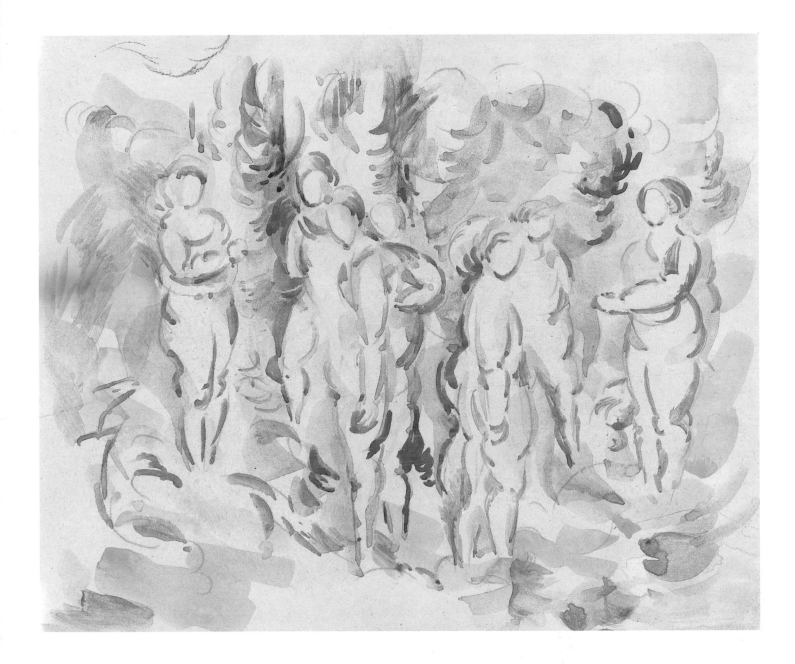

Autumn foliage

Size: 245 × 300mm (9¾ × 12in)
Colours: lemon yellow, cobalt blue, rose madder, yellow ochre, burnt umber

In this photograph, the vegetation covers the entire surface like a pattern. It is easy to imagine Cézanne being attracted to this type of landscape and rendering it in watercolour.

When creating your composition, try to capture the atmosphere and beauty of nature using fluid brush strokes. It is not necessary to stick slavishly to what you actually see before you.

Stage 1
Apply a soft ground of burnt umber and a little yellow ochre before making a bold sketch on the watercolour paper.

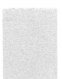

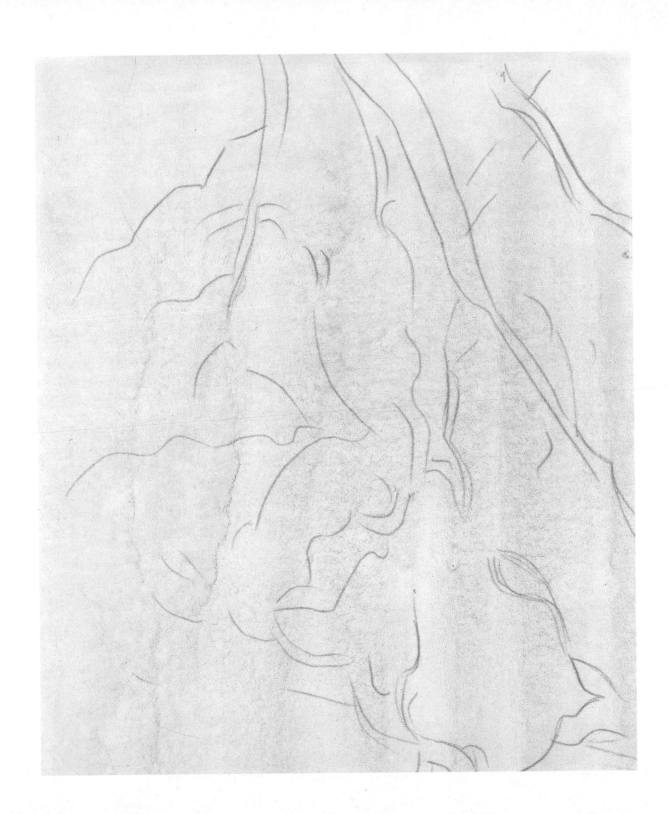

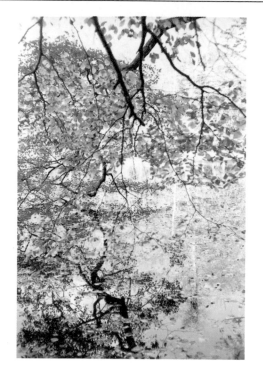

Stage 2

Define the structure of the picture with cobalt blue and a trace of burnt umber. As soon as these washes are dry, apply fine brush strokes of the same tone to a few points.

Use yellow ochre mixed with lemon yellow for the soft, yellow autumn leaves. The warm, reddish-brown tones of the foliage can be mixed from yellow ochre and rose madder. Apply a mixture of burnt umber, rose madder and cobalt blue to provide another coloured effect on the foliage.

The branches, which extend over the entire surface and give a definite structure to the picture, are painted in a dark tone mixed from yellow ochre, cobalt blue and rose madder.

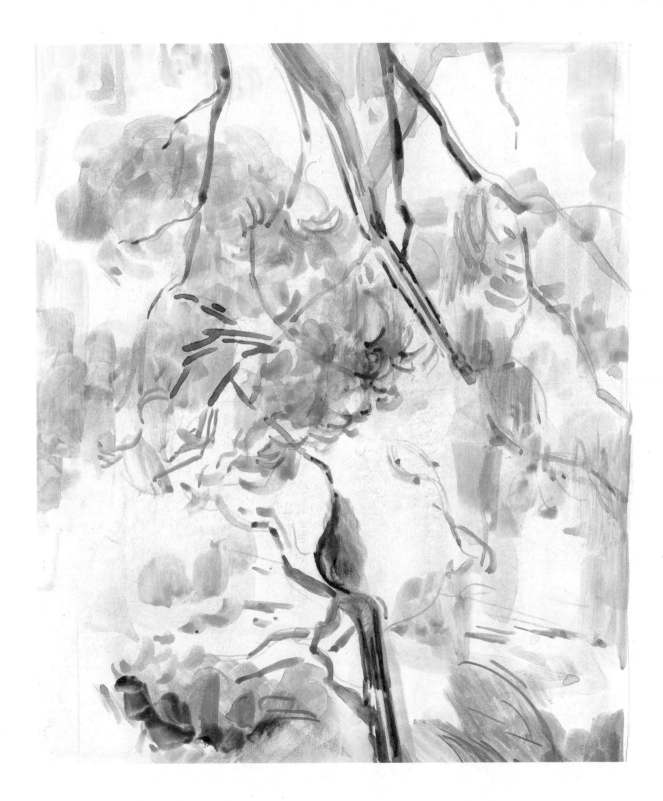

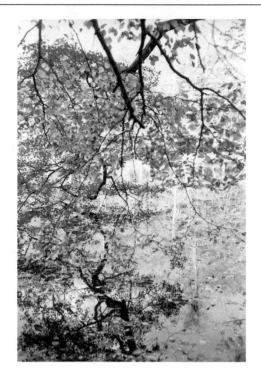

Stage 3 – the finished painting

You can reproduce the green tone of the photograph with a mixture of cobalt blue and lemon yellow. Alternatively, use pure French green. Like the other colours, this green tone is repeated over the picture surface.

To obtain a harmonious overall effect, lighten the dark, rigid lines here and there by moistening the paint with a water brush and then applying a dry brush. At other points, use a fine brush to add more structural lines in pure cobalt blue, thus reproducing the soft tracery of the branches. These graphic elements give a certain dynamism to the static subject-matter.

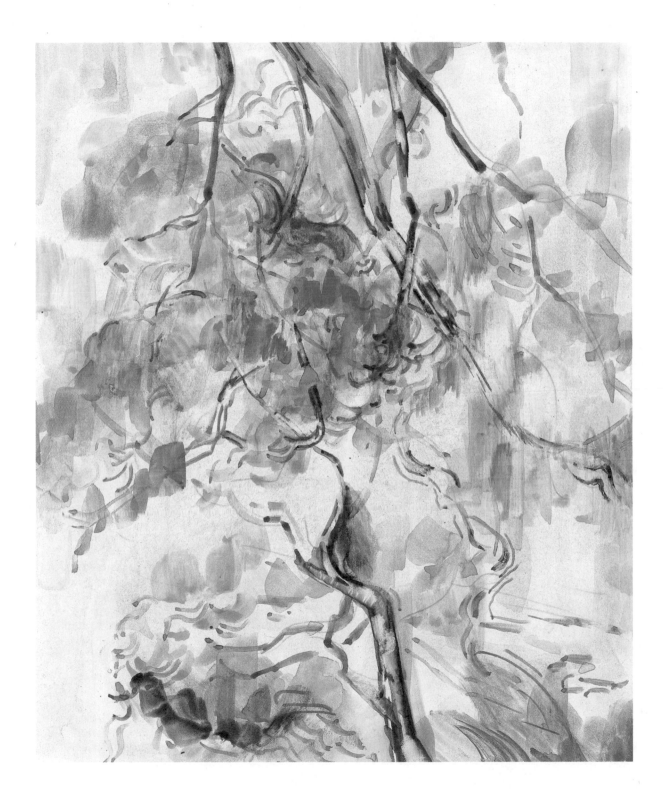

First published in Great Britain 1992
Search Press Ltd.,
Wellwood, North Farm Road,
Tunbridge Wells, Kent TN2 3DR

Originally published in Germany, under the title *Malen wie die Meister/Aquarellmalerei im Stil von Paul Cézanne*, by Christophorus-Verlag GmbH, Freiburg im Breisgau

Copyright © 1991
Christophorus-Verlag GmbH, Freiburg im Breisgau

English translation copyright © 1992
Search Press Ltd.

Translated by John Griffiths

ILLUSTRATIONS: page 7, *Provençal landscape* (*Paysage en Provence*, c.1878) by Paul Cézanne, watercolour on cardboard, 499 × 346mm (20 × 13¾ in), copyright © Kunsthaus Zurich; page 65, *Male Bathers* (*Baigneurs*, 1896–7) by Paul Cézanne, watercolour over pencil, 272 × 200mm (11 × 8in), private collection.
PHOTOGRAPHS: pages 36, 44 and 74, Rosemarie Heuer; pages 46, 50 and 56, Archiv HSL; page 66, DLRG, Bonndorf.

If this book is used for teaching purposes, then please acknowledge the series *Learn from the Masters*.

Publishers' note
There are references to animal hair brushes in this book. It is the Publishers' custom to recommend synthetic materials as substitutes for animal products wherever possible. There are now a large number of brushes available made of artificial fibres and they are just as satisfactory as those made of natural fibres.

ISBN 0 85532 723 5

Composition by Genesis Typesetting, Rochester, Kent
Printed in Germany

Other books published by Search Press

LEARN FROM THE MASTERS
Other titles in this series include:
Volume 1 Turner;
Volume 3 Van Gogh;
Volume 4 Gauguin.

Using a simple, easy to understand approach, each volume reconstructs a popular watercolour painting and shows how, using these techniques, you can produce your own contemporary painting in the style of one of these Great Masters.

LEISURE ARTS
There are over 30 titles in this popular, widely acclaimed series of oil, watercolour, pastel, gouache and acrylic teach-yourself painting books. All the secrets of successful painting are clearly explained by well-known artists, together with step-by-step full colour demonstrations.

UNDERSTAND HOW TO DRAW
This series of 'how-to-draw' books is written and illustrated with sketches and drawings by professional artists to encourage the beginner to develop his or her drawing skills. Many different techniques and methods are explained, and a broad selection of subjects is covered, such as trees, flowers and plants, buildings, landscapes and animals.

KEY TO ART
These beautifully illustrated, pocket guide books are for art lovers and art students alike. There are six titles in the series, covering Renaissance art, romantic and impressionist art, Gothic art, modern art and baroque art. Each title provides a comprehensive background and brief history of the subject, and all are illustrated with a wealth of photographs of selected masterpieces to highlight important points.

There are many other painting, drawing and calligraphy titles published by Search Press. If you would like to receive a free copy of our colour catalogue and information about how to order, write to Dept B, Search Press Ltd., Wellwood, North Farm Road, Tunbridge Wells, Kent TN2 3DR, England. Telephone 0892 510850.